一種

たゆきを
ぬもう

きしゆう

KEW POCKETBOOKS

HONZŌ ZUFU

本草図譜

Introduction by Martyn Rix and Masumi Yamanaka

Curated by Gina Fullerlove

Kew Publishing
Royal Botanic Gardens, Kew

一種

こびうめ

諸家數たちうめと称ふて太宰府小二品の子にして此物ちりて草辨ちちて草辨及ひ辨の先淡紅薔薇及ひ辨の先紅色ありて一に常の野梅ありて一に常の野梅梅なり

KEW HOLDS ONE OF THE LARGEST COLLECTIONS of botanical literature, art and archive material in the world. The library comprises 185,000 monographs and rare books, around 150,000 pamphlets, 5,000 serial titles and 25,000 maps. The Archives contain vast collections relating to Kew's long history as a global centre of plant information and a nationally important botanical garden including 7 million letters, lists, field notebooks, diaries and manuscript pages.

The Illustrations Collection comprises 200,000 watercolours, oils, prints and drawings, assembled over the last 200 years, forming an exceptional visual record of plants and fungi. Works include those of the great masters of botanical illustration such as Ehret, Redouté and the Bauer brothers, Thomas Duncanson, George Bond and Walter Hood Fitch. Our special collections include historic and contemporary originals prepared for *Curtis's Botanical Magazine*, the work of Margaret Meen, Thomas Baines, Margaret Mee, Joseph Hooker's Indian sketches, Edouard Morren's bromeliad paintings, 'Company School' works commissioned from Indian artists by Roxburgh, Wallich, Royle and others, and the Marianne North Collection, housed in the gallery named after her in Kew Gardens.

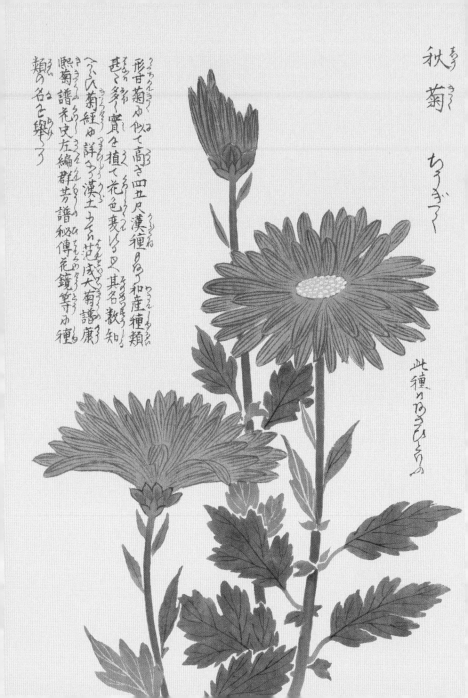

秋菊 ちうぎく

形晋菊ゟ似て高さ四五尺漢種ゟ和産種類
甚て多く實を植て花色変ハる又其名数知
〳〵此菊経ゟ詳かニ漢土ニて范成大菊譜廉
熙菊譜花史左編群芳譜秘傳花鏡等ゟ種
類の名を挙く

此種りなき花といゝの

INTRODUCTION

本草図譜

THE SET OF HONZŌ ZUFU HELD IN KEW'S LIBRARY,
Art and Archives is one of its greatest treasures. Its title
translates as 'illustrated manual of medicinal plants' and
it dates from the late Edo period (1603–1868). It is printed
in 92 volumes, on double leaves of manuscript in Japanese
style, with Japanese script.

Its author Tsunemasa Iwasaki (1786–1842) is more
often known as Kan-en Iwasaki or simply as Kan-en, a
pseudonym that means 'irrigation of a garden for plants'.
A samurai in service of the Tokugawa Shogunate and
a born naturalist, he was interested in plants from his
youth, collecting flowers and herbs in the districts near
Edo (the capital of the Tokugawa Shogunate, now Tokyo).
He also grew medicinal plants in his home garden and in
a field borrowed from the Shogunate.

Kan-en finished the original *Honzō Zufu* in 1828 and it
was published between 1830 and 1844, completed by his
son Nobumasa. It comprises some 2,920 illustrations,
showing both skill and creativity. The text for each plant
is short, giving the name, sometimes the origin, and
important details such as size and flowering time.

The first four parts, issued in 1830, were illustrated with hand-coloured woodblock prints. Thereafter, the volumes were essentially all manuscript, with text written using a fine brush and beautifully hand-painted watercolour illustrations. These were distributed to subscribers at a rate of about four a year. One set is said to have been presented to the Shogun.

Authentic copies of *Honzō Zufu* were produced partially by Kan-en himself and by hired painters working under his supervision. Only a few complete authentic sets survive; six are in Japan and even fewer in the rest of the world. Authentic copies bear two types of seal. One, Uchu Ippon Iwasaki Hikkyu, is placed on the inside cover of each volume and considered to be a copyright declaration. All but eight of the volumes in the set given to Kew are authentic.

Although originally a herbal, *Honzō Zufu* became a guide to all plants cultivated in Japan during the first half of the 19th century. Even today it is recognised as an important source of names and dates of old Japanese cultivated plants, as well as an indication of the introduction date of foreign plants.

The Japanese tradition of using medicinal herbs derived from China and was associated with Confucianism. Throughout the Edo period the work regarded as the

Bible of herbalism was *Ben Cao Gang Mu* (Compendium of Materia Medica) edited by the Chinese doctor and herbalist Li Shizhen (1518–1593) and known in Japanese as *Honzō Kōmoku*. The botanist Ranzan Ono (1729–1810) studied *Honzō Kōmoku* and considered how it could be adapted for Japanese wild plants. Kan-en Iwasaki studied under Ranzan Ono for a year, and used *Honzō Kōmoku* as the basis for the composition and arrangement of plants in *Honzō Zufu*.

Given how the isolationist Sakoku policy (officially rescinded in 1853) limited plant introductions, Japanese gardeners and plant lovers developed plants already in cultivation. Hydrangeas were widely grown, the mop-headed sterile varieties developing from the wild lace-cap shape. Early spring flowers were especially valued; numerous colour forms of *Hepatica nobilis* are still avidly collected and grown by specialists. Lilies were also popular, especially the red-striped form of *Lilium auratum*, and double forms of the tiger lily. The pinks shown on page 37 were derived from hybrids between *Dianthus chinensis* and the Japanese *D. superbus*, with finely-divided petals. Two Japanese species of the Solomon's seal (*Polygonatum involucratum* and *P. humile*) whose rhizome is used in China, are shown on page 12. The shrub *Nandina domestica* was also popular and many different forms were cultivated; the form on page 88 is so unusually contorted that it was initially difficult to identify.

Ancient introductions from China were an important source of traditional garden plants for Japanese gardeners, who selected odd mutations and bred new varieties. The most popular were the many varieties of chrysanthemum, the early-flowering plum *Prunus mume*, tree peonies, camellias and roses. The double form of the pomegranate also came to Japan via China from its original habitat in western Asia, as did the opium poppy, the one shown on page 61 being ornamental rather than medicinal. This route was probably also followed by one of the most ancient cultivated plants, the garden pea (*Pisum sativum*), a native of western Mediterranean. Chinese medicinal plants were also widely grown. The common Chinese medicinal fritillary, *Fritillaria thunbergii*, was named from Japanese cultivated plants, but the specimen painted on page 21 looks like a rarer species from eastern China, *F. anhuiensis*.

Despite the Japanese government's attempt to keep out foreign (and particularly European) influence, by the 1830s more new plants were creeping into Japanese gardens and being cultivated alongside the traditional varieties. Some originated in South Africa, probably brought by the Dutch from their colony at the Cape, an important stopping point for ships sailing between Holland and Japan. By 1830 we have pictures of a very un-Japanese-style bulb, the blood lily (*Haemanthus coccineus*), from the Cape district of South Africa, and of other African plants such as the

ornamental evergreen shrub, *Leucadendron salignum.* Few illustrated plants originated in the Americas, in spite of being common in India by this time, but there is a coloured maize, which was probably grown as a curiosity rather than as food.

To a European eye these paintings may seem very stylised, but all can be accurately identified without understanding the Japanese names. Although the Japanese established and continue to use a different but equally accurate naming system, in 1829 the noted doctor and naturalist Keisuke Ito (1803–1901) brought together the Linnean Latin names and Japanese names.

Decades later, on 3rd June 1886, Keisuke wrote to his grandson, the botanist Tokutaro Ito (1866–1941) who was at the time studying at Kew and Cambridge, that he was sending him a set of *Honzō Zufu.* So that it may become better known outside Japan, Tokutaro donated the set to Kew, presenting this precious gift to the Herbarium on 7 December 1886.

Martyn Rix
Editor, *Curtis's Botanical Magazine*

Masumi Yamanaka
Botanical artist, Royal Botanic Gardens, Kew

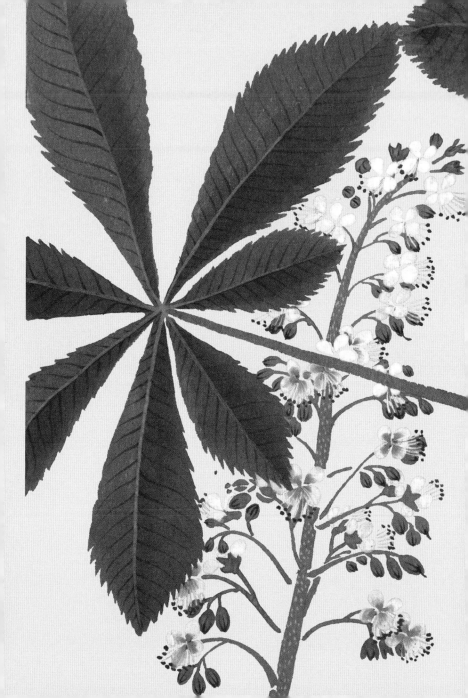

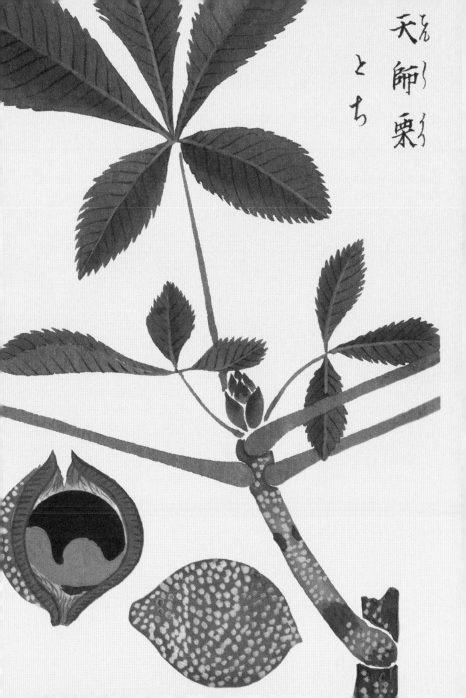

天師栗
とち

Polygonatum involucratum and *P. humile*

narukoyuri, Solomon's seal

Volume 5

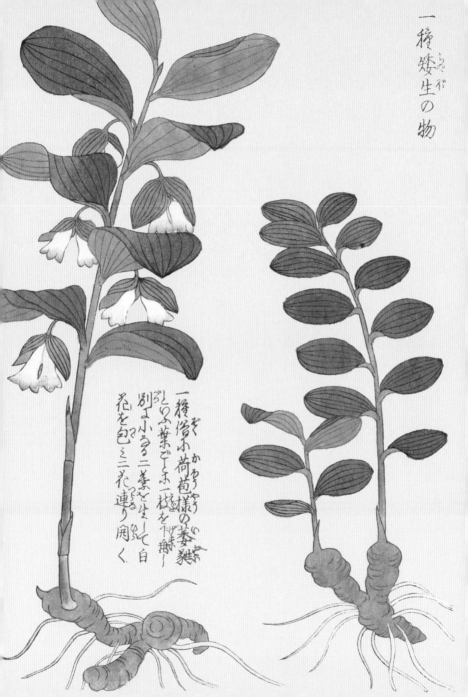

一種矮生の物

一種偐小荷葩樣の姜襲
として葉ごとに一枝を下げ無し
別よ小るゝ二葉を生して白
花を包ミ三花連り開く

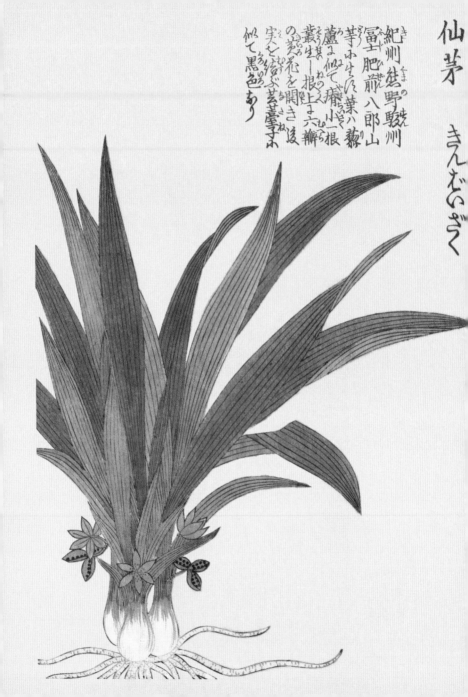

仙茅　きんむいざく

紀州熊野駿州
冨士肥前八郎山
芋小生ズ葉ハ藪
蘆ニ似テ癤小サ
叢生シ根ハ上ズ六瓣
の花を開き後
実を結ぶ芸薹子ニ
似て黒色あり

Curculigo orchioides

kinbaizasa, golden eye-grass

———

Volume 6

Bletilla striata

shiran, urn orchid

———

Volume 6

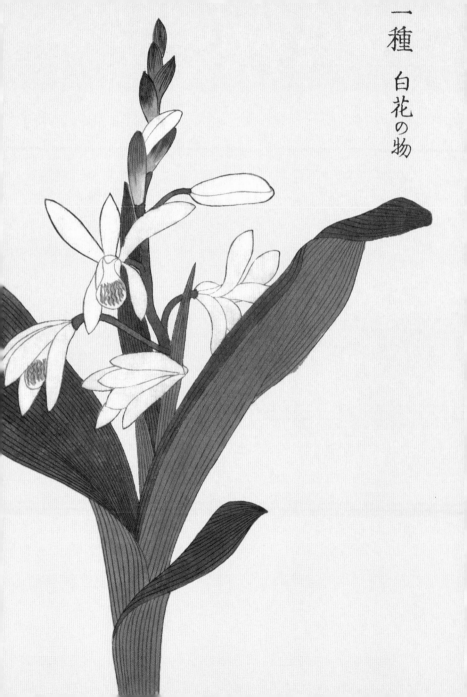

一種　白花の物

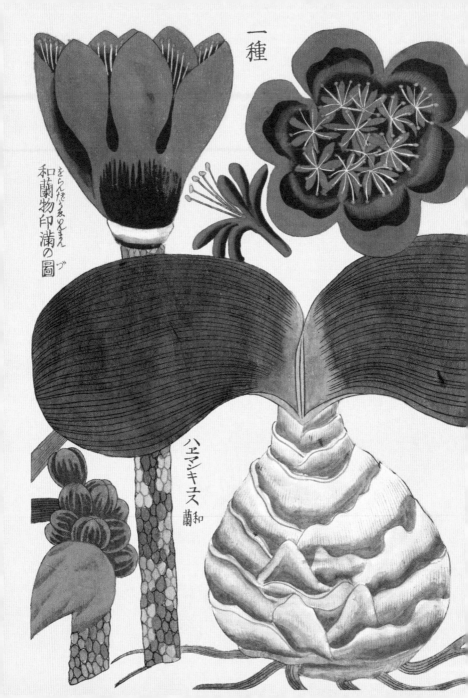

一種

をらんだうゑとまん
和蘭物印滿の圖
づ

ハヱマンキユス
蘭和

Nº 4

Haemanthus coccineus

blood flower, blood lily

—————

Volume 7

Nº 5

Fritillaria anhuiensis

baimo, fritillary

———

Volume 7

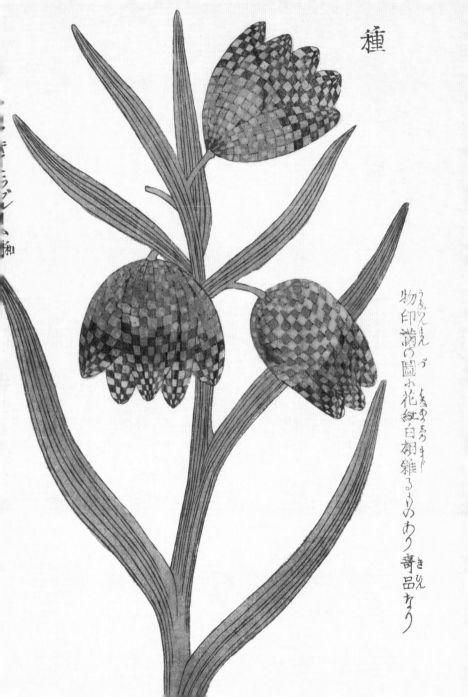

種

物印満の圖ふ花紅白相雜るゝのあり稀品たり

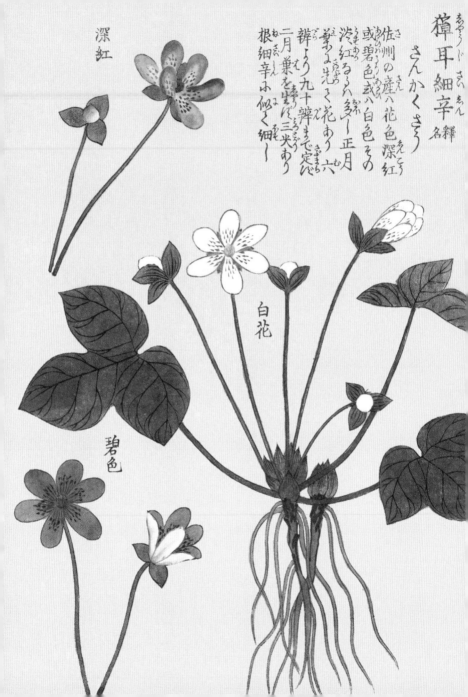

深紅

白花

碧色

獐耳細辛　名稱

さんかくさう

佐州の産ハ花色深紅
或ハ碧色或ハ白色その
深紅なるハ多し一正月
葉よく茂く花あり六
辨より九十辨まで定び
二月葉を生じ三尖あり
根細辛ふ似く細く

Hepatica nobilis var. *japonica*

yukiwariso, Japanese hepatica, variations with
scarlet, white and deep blue flowers

———————

Volume 8

蘹
�

かんぜきらん

N° 7

Phaius flavus

kanzekiran, orchid

———

Volume 10

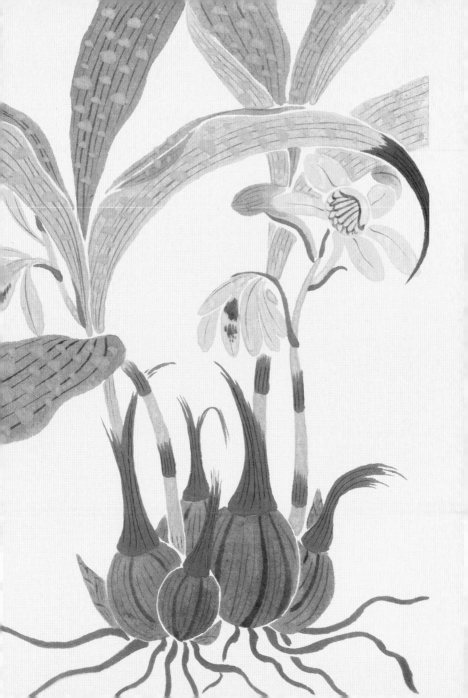

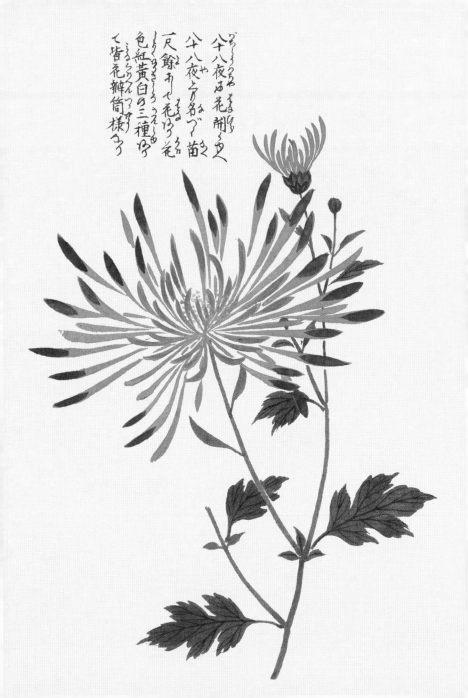

八十八夜頃より花開く色
八十八夜とも名づ苗
尺餘わ八花は花
色紅黄白の三種わ
て皆花辨筒横ろ

Chrysanthemum x morifolium

kiku, spider chrysanthemum

Volume 13

Leonurus macranthus f. *alba*

kaenkisewata, large-flowered leonurus

———————

Volume 14

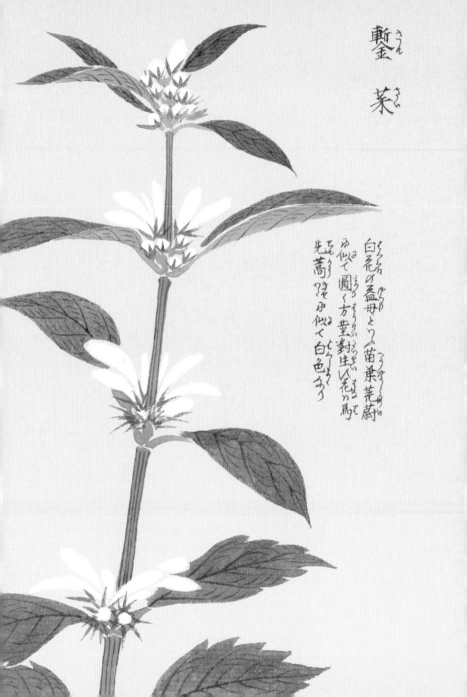

白花の益母とりの苗葉荒蔚
ゆ似て圓く方莖對生い花か馬
先蒿祭を似て白色なり

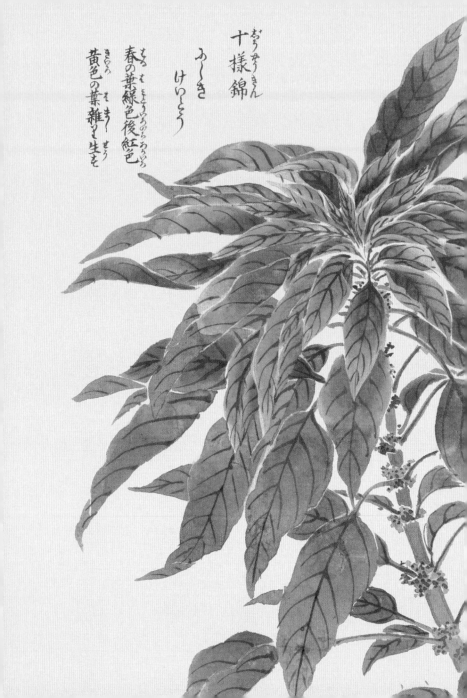

おうみうきん
十様錦

ふ〜き
けいとう

春の葉緑色後紅色
黄色の葉雑と生を

Amaranthus tricolor

hageito, Joseph's coat amaranth

———————

Volume 15

Nº 11

Iris sanguinea

ayame, blood-red iris

———————

Volume 16

一種

かまやまあやうぶ

琉球釜山より来るとて兼行にあり

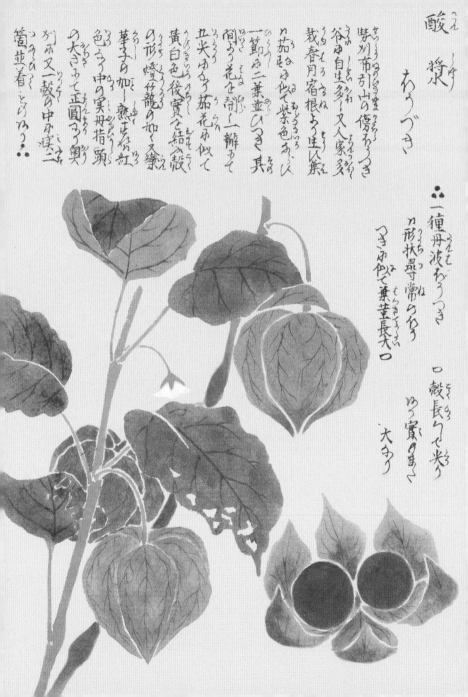

酸漿
ほうづき

Physalis alkekengi var. *franchetii*

hozuki, Chinese lantern

––––––––

Volume 17

Dianthus superbus var. *longicalycinus* and *D. chinensis* hybrids

nadeshiko, fringed pinks

Volume 18

石竹を同物とさせり誤る事　さく通雅の辨い

一種　きりあそ一と

石竹通　名

一名　大南竹　耶典府志

海邊の砂地る軍江戸本所みて多栽の花色多草花譜の紅麥の類

一種　いきうに又もあげとり云

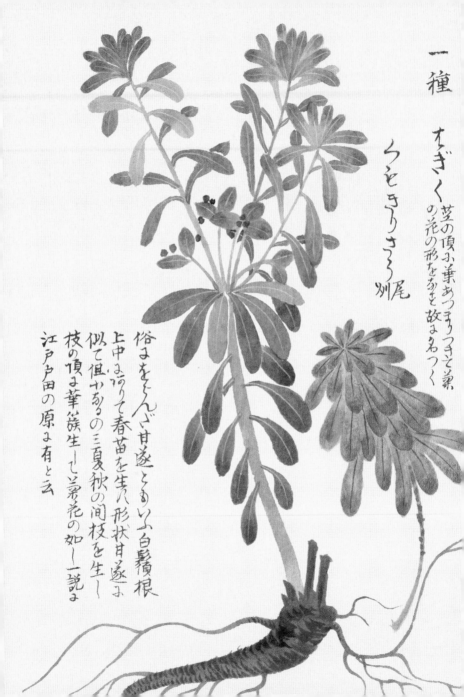

一種　オギク　茎の頂ふ葉あつまりつきて葉の花の形をかをと故ふ名つく

うとぎりさう別尾

俗ふをとんざ甘遂ともいふ白鬚根
上中ふ詞りて春苗を生ハ形状甘遂ふ
似て但かある三夏秋の間枝を生し
枝の頂ふ華簇生一し兼花の如し一説ふ
江戸田の原ふ有と云

Euphorbia esula subsp. *esula*

todaigusa, spurge

———————

Volume 21

Hydrangea serrata var. *japonica*

benigaku, gaku-ajisai, hydrangea

Volume 21

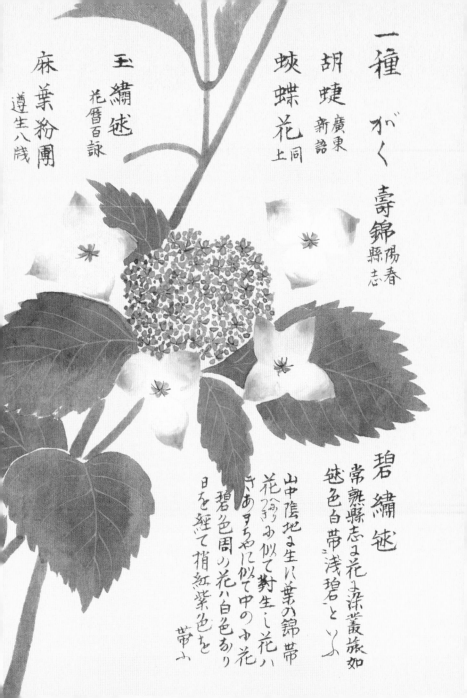

一種　がく　壽錦 陽春縣志

蛺蝶花 同上

胡蜨 廣東新語

玉繡毬 花暦百詠

麻葉粉團 遵生八牋

碧繡毬

常熟縣志ニ花ハ深叢蔟旅如
毬色白帶ニ淺碧ニとふ

山中陰地ニ生ズ葉ハ茉の錦帯
花ヘハり〻ニ似て對生し花ハ
きあすちやに似て中の小花
碧色周ノ花ハ白色あり
日を經て稍紅紫色を
帯ハ

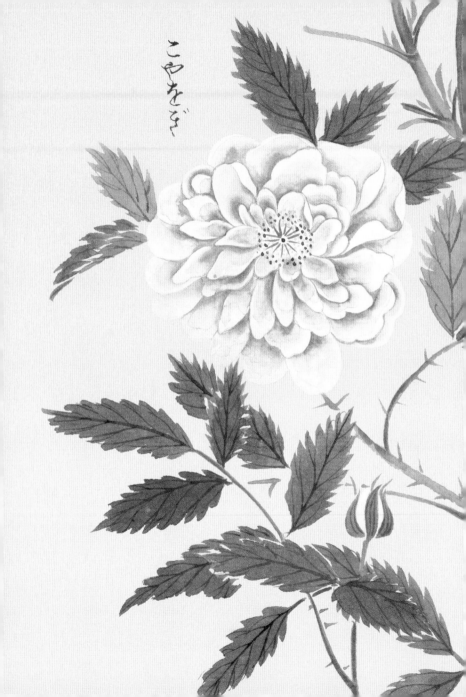

Rubus rosifolius 'Coronarius'

tokin-ibara, briar rose

———————

Volume 25

Rosa chinensis

koshinbara, China rose

———————

Volume 27

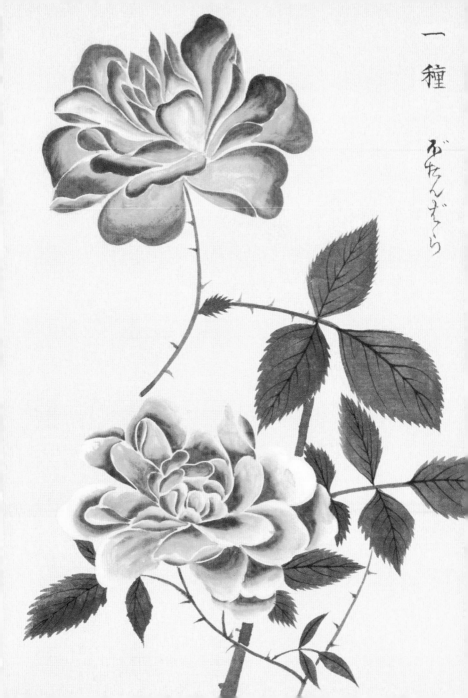

一種

ぼたんざくら

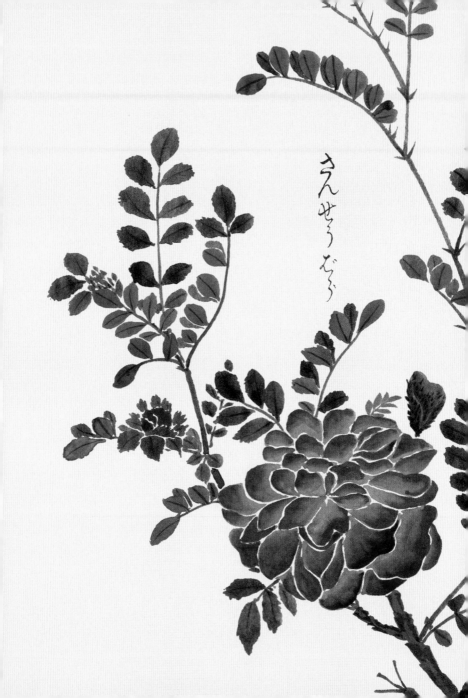

さんせうむそう

Rosa roxburghii

izayoibara, burr rose, chestnut rose

Volume 27

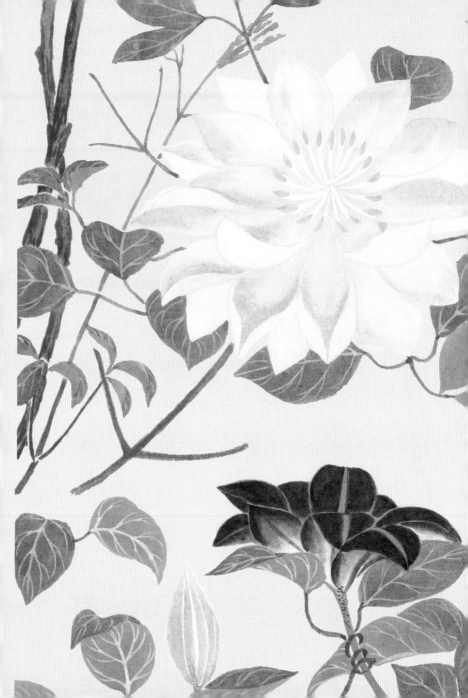

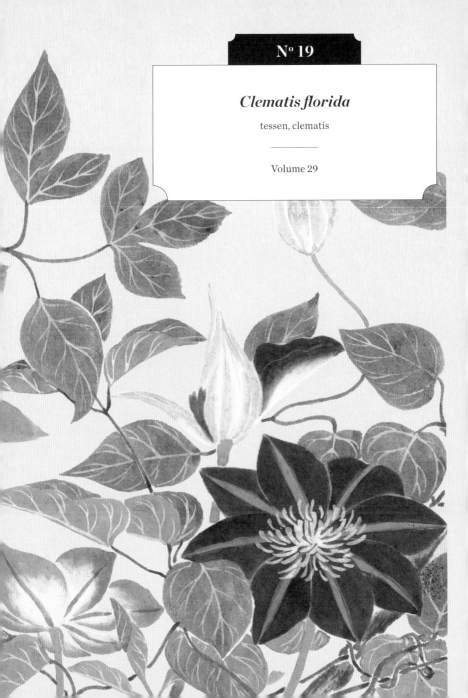

Clematis florida

tessen, clematis

———

Volume 29

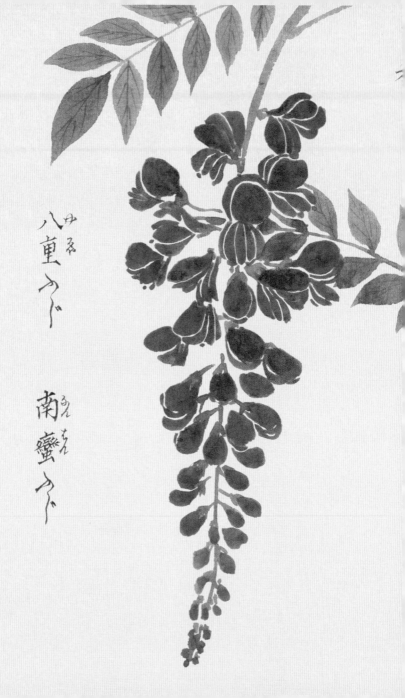

八重ふぢ

南蠻ふぢ

Wisteria sinensis

fuji, Chinese wisteria

———————

Volume 32

Nº 21

Pontederia korsakowii

hotei-aoi, water hyacinth

———————

Volume 33

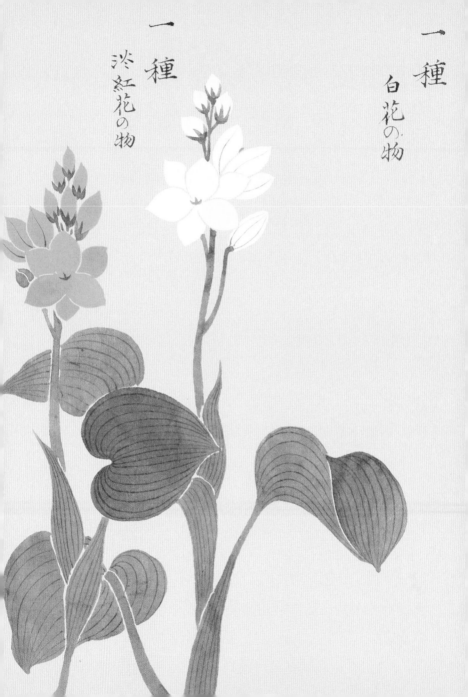

一種　白花の物

一種　淡紅花の物

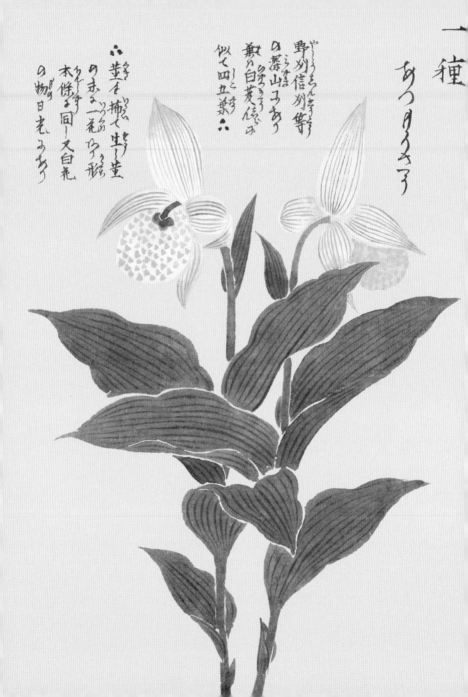

一種

あつもりさう

やまぶきさうあつもりさう
野刈信別等
の深山ニあり
しろうもゝ
かいこいろ
輙ハ白芰復ゞ
似て四五葉ハ

六葉を捕て壺ノ莖
の末ニ一花ゝ形
本條ゞ同一又白花
の物日光ゞあり

Cypripedium macranthos
var. *speciosum*

atsumoriso, Japanese slipper orchid

Volume 39

早中晩の三種
にり初夏　種を
下ひ粒細かにして
毛茸あく深黄色あ〜
中うくろうあひ又ニせん
あるゝをと云ハ粗小く色
白ゝ古説染染の集解の白
染るゝそれをし檀うれハ今
当よ玖む革夷老よ有浅膏色
白如銀とゝり

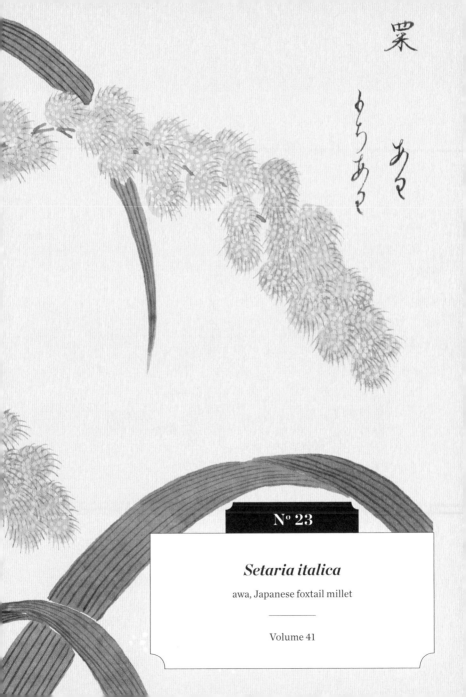

罘

もらあら

Nº 23

Setaria italica

awa, Japanese foxtail millet

———

Volume 41

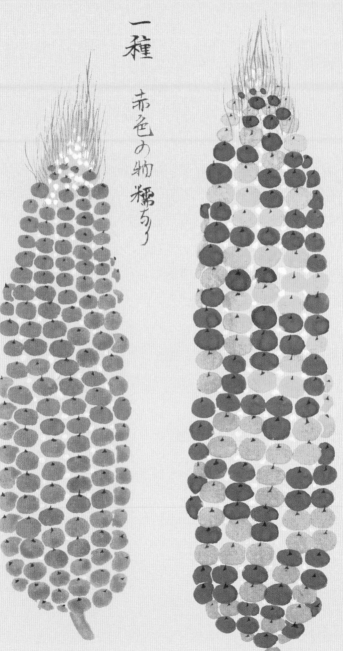

一種　赤色の物　糯なり

一種　紫色黄白色相雜る物

Zea mays

tomorokoshi, maize, sweetcorn

Volume 41

Papaver somniferum

keshi, opium poppy

Volume 42

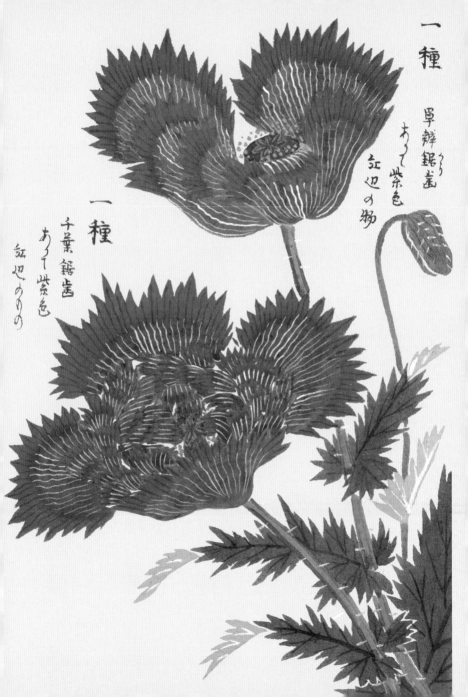

一種

單瓣鋸歯
あって紫色
紅辺の物

一種

千葉鋸歯
あって紫色
紅辺のりの

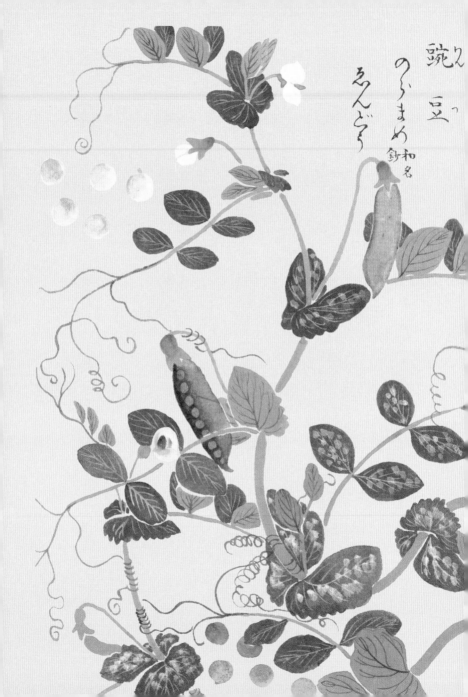

豌
豆

のらまめ

ゑんどう

和名

釣

Pisum sativum

endo, garden pea

Volume 43

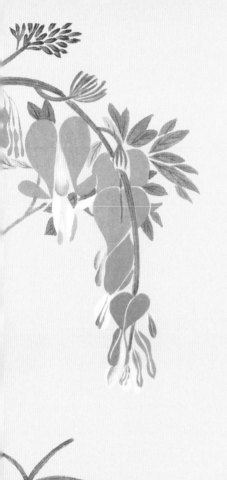

けまんそう

№ 27

Lamprocapnos spectabilis

kemanso, bleeding heart

———

Volume 48

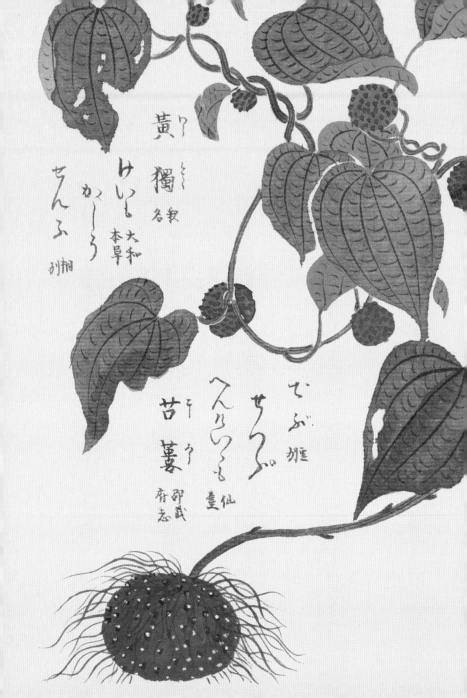

黄獨

けいも
かしう
さんふ

名義
大和本草
別桐

苦薯

てぶ姫
せうぶ
へんらつも
童仙
卯武
府志

Nº 28

Dioscorea bulbifera

nigakashu, air potato

———————

Volume 50

Lilium lancifolium 'Flore Pleno'

oniyuri, tiger lily

Volume 51

一種

八重卷丹

形状 前條ニ
同クシテ唯花
千葉ナリ

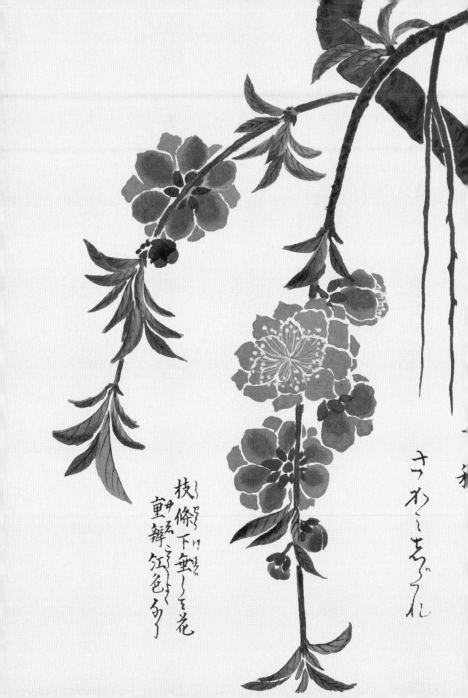

枝條下垂して花
重辨にして紅色多く

カラこまつぶれ

Prunus persica 'Sagami-shidare'

hana-momo, flowering peach

Volume 62

Punica granatum

zakuro, pomegranate

Volume 64

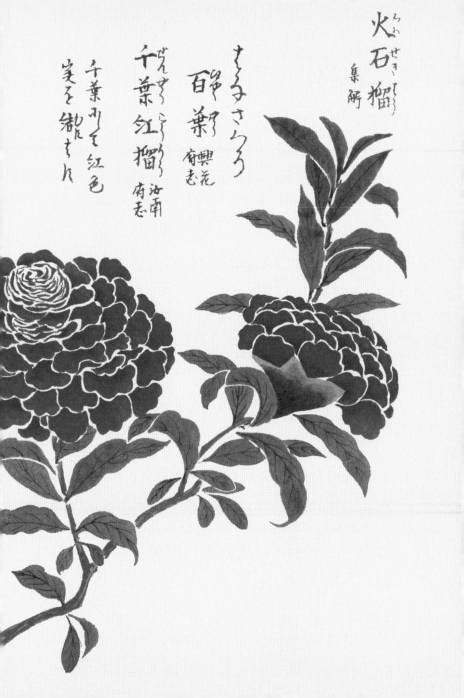

火石榴
　集解

さるすべり
百日紅　羣芳譜

千葉紅榴　海南
千葉刈て紅色
実を觀もん

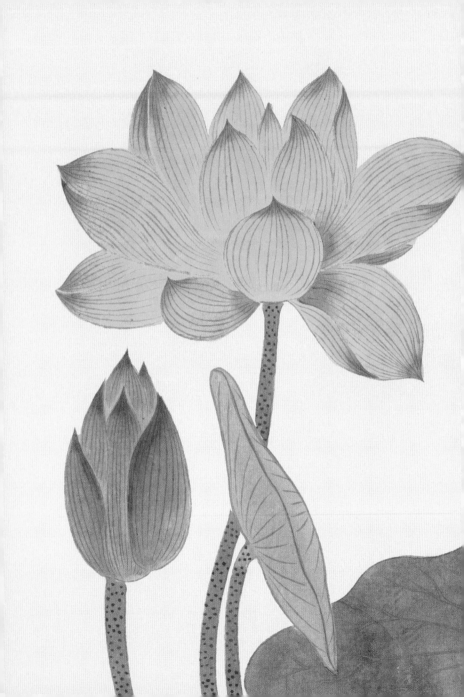

Nelumbo nucifera

hana-basu, ornamental lotus

———

Volume 72

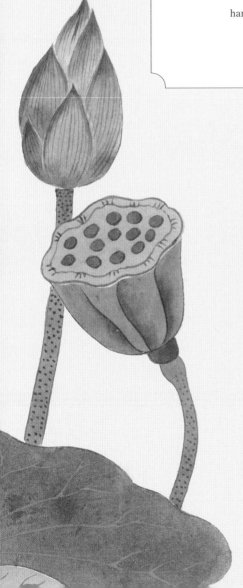

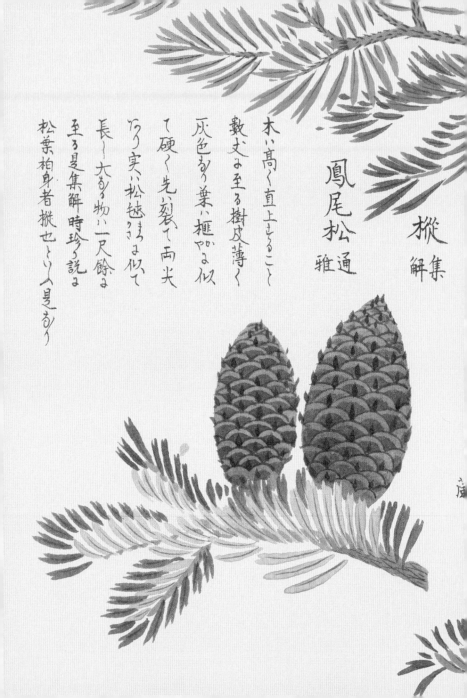

鳳尾松 通
雅

木ハ高く直上すること
數丈ニ至る樹皮薄く
灰色なり葉ハ樅やニ似
て硬く先ハ裂て兩尖
なり實ハ松毬なるニ似て
長く大なる物ハ一尺餘ニ
至る是集解ニ時珍ノ説ニ
松葉柏身者樅也とハ見えす

N° 33

Abies firma

momi, momi fir

Volume 78

Leucadendron salignum

ginyoju, sunshine conebush

———————

Volume 82

一種

物印忙ふ
載に圖葉
の形㯃か
て中ハ青色
中ハ紅色之
葉の間毯
あろ花実
何れろ〱や
分明か〱

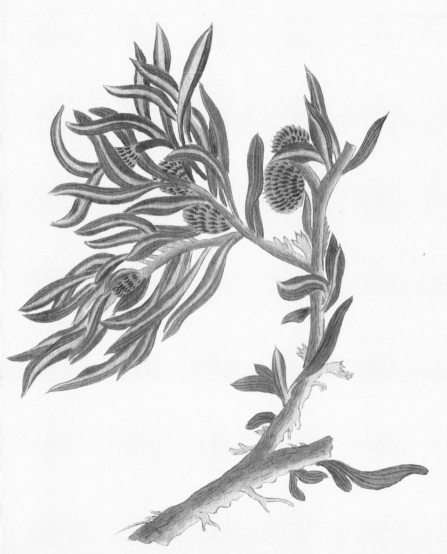

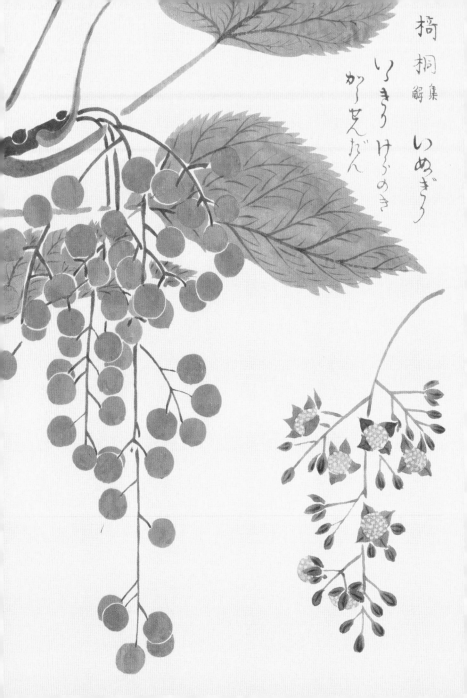

Idesia polycarpa

li-giri, igiri, wonder tree

Volume 63

Zelkova serrata

keyaki, Japanese zelkova, Japanese elm

Volume 84

一種

葉の形前條に

の如くして秋

月に到り面黄

褐色背り淡

紅色み帯ぶ

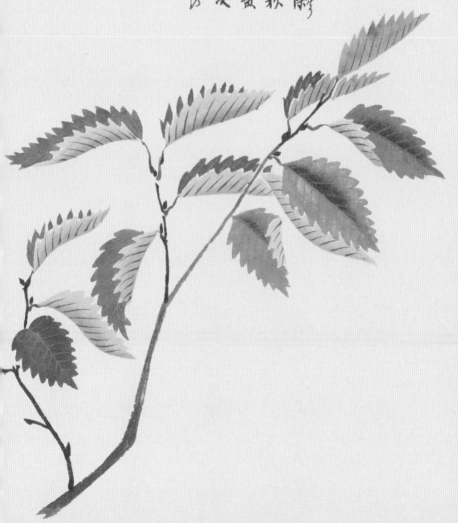

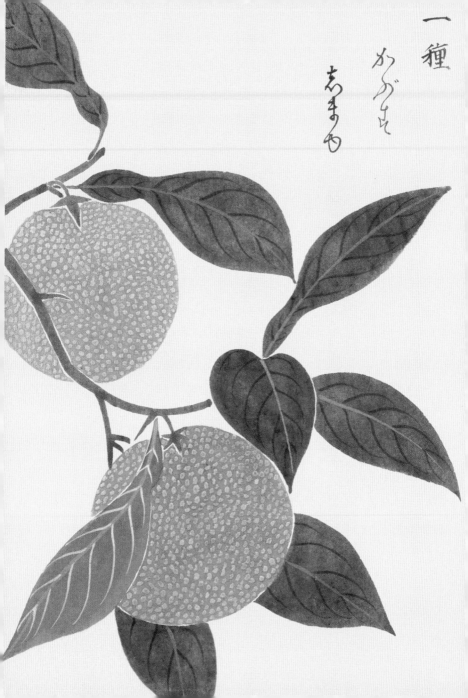

一種

かうぢ

そ
志まの

Citrus x *aurantium*

dai-dai, orange,
cultivar of the mandarin-pomelo hybrid complex

Volume 87

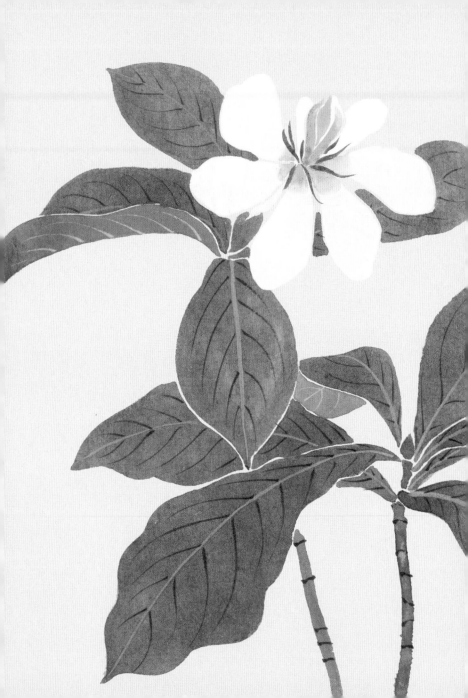

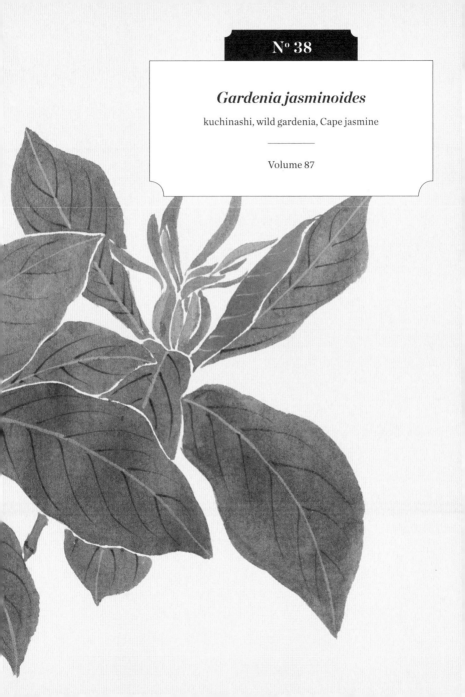

N.º 38

Gardenia jasminoides

kuchinashi, wild gardenia, Cape jasmine

———

Volume 87

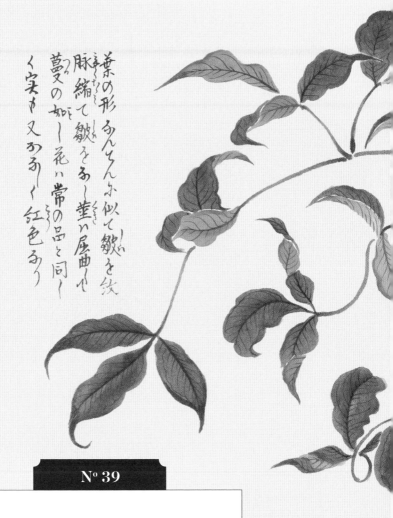

葉の形ちんそんふ似て皺を放
脉縮て皺をなし茎い屈曲く
蔓の如し花い常の品と同く
く実も又あふく紅色あり

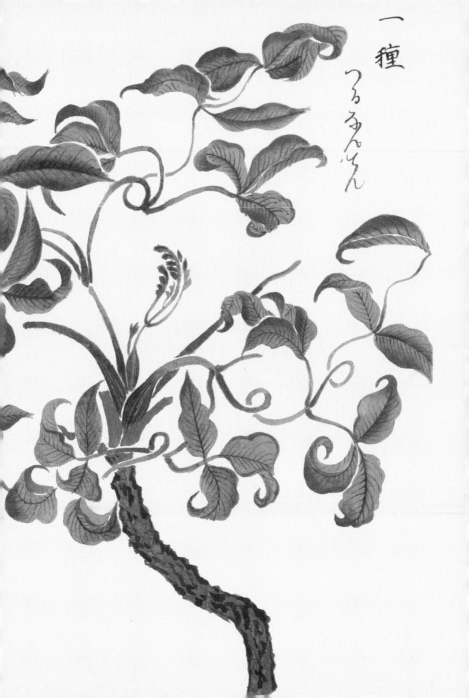

一種

つるゝんさん

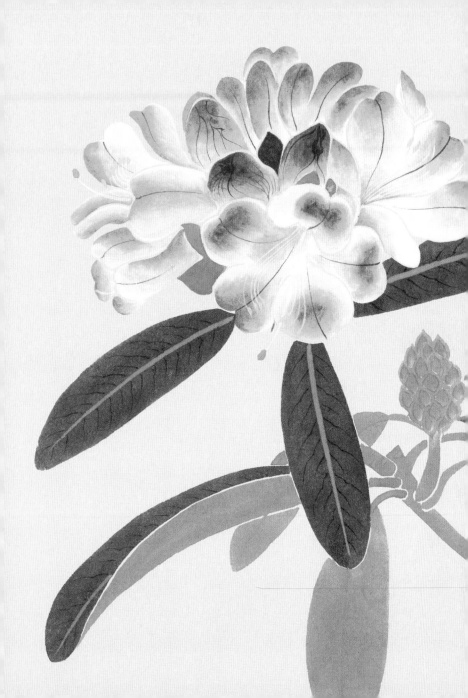

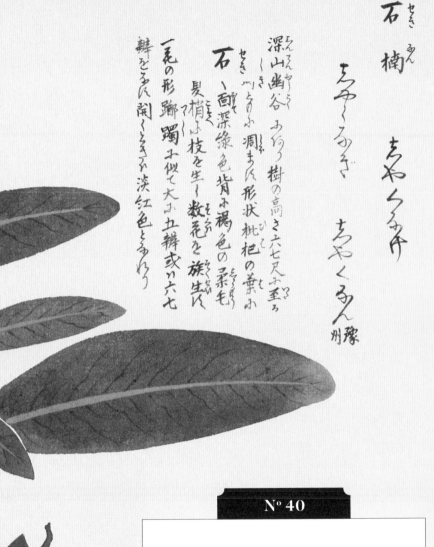

石楠 せきなん

しゃくなけ

しゃくなんげ

しゃくなん 豫州

深山幽谷みちる樹の高さ六七尺ふ至ろ
せきなんふ測まに形状枇杷の葉ふ

石〜酩深緑色背ふ褐色の柔毛
髪梢ふ枝を生〜数花を簇生に
一花の形躑躅ふ似て大ふ五辮或り六七
辮を五民開くときふ淡紅色とふるり

N° 40

Rhododendron degronianum

azuma shakunage, rhododendron

———

Volume 89

ILLUSTRATION SOURCES

Iwasaki, Kan'en and Iwasaki, Nobumasa. (1828–44). *Honzō Zufu* 92 volumes (numbered 5 to 96; original volumes 1 to 4 do not exist).

Part 1. Herbs

(1) Mountain herbs Vol. 5–8
(2) Fragrant herbs Vol. 9–12
(3) Marshland herbs Vol. 13–20
(4) Toxic herbs Vol. 21–24
(5) Creeping herbs Vol. 25–32
(6) Aquatic herbs Vol. 33–34
(7) Stone herbs Vol. 35–37
(8) Lichens Vol. 37–38
(9) Miscellaneous herbs Vol. 39

Part 2. Grains

(1) Hemp, wheat, rice Vol. 40
(2) Millets Vol. 41–42
(3) Beans Vol. 43
(4) Yeast Vol. 44

Part 3. Vegetables

(1) Strong smelling spices Vol. 45–47
(2) Soft vegetables Vol. 48–52
(3) Melons Vol. 52–53
(4) Watery vegetables Vol. 54
(5) Sesame and nuts Vol. 55–60

Part 4. Fruits

(1) The five fruits (plum, apricot, prune, peach, chestnut) Vol. 61–62
(2) Mountain fruits Vol. 63–66
(3) Foreign fruits Vol. 67–69
(4) Tasty fruits Vol. 70
(5) Melons Vol. 71
(6) Watery fruits Vol. 72–76

Part 5. Trees

(1) Fragrant trees Vol. 77–81
(2) Large trees Vol. 82–86
(3) Shrubs Vol. 87–92
(4) Annual shrubs Vol. 93
(5) Bamboos Vol. 94–95
(6) Textiles, Various objects Vol. 96

FURTHER READING

Abe, Naoko. (2019). '*Cherry' Ingram: The Englishman who Saved Japan's Blossoms*. Chatto & Windus, London.

Casserley, Nancy Broadbent. (2013). *Washi: The Art of Japanese Paper*. Royal Botanic Gardens, Kew.

Kashioka, Seizo and Ogisu, Mikinori. (1997*). Illustrated History and Principle of the Traditional Floriculture in Japan*. Seizo Kashioka in collaboration with Kansai Tech Corporation, Osaka.

Kew Pocketbooks. (2020). *Japanese Plants*. Royal Botanic Gardens, Kew.

Kirby, Stephen, Doi, Toshikazu, Otsuka, Toru. (2018). *Rankafu Orchid Print Album: Masterpieces of Japanese Woodblock Prints of Orchids*. Royal Botanic Gardens, Kew.

Siebold, Philipp Franz von, Miquel, Friedrich Anton Wilhelm, Zuccarini, Joseph Gerhard. (1835-70). *Flora Japonica*. Lugduni Batavorum.

Tajima, Kazuhiko (Art Director). (2019). *Flowers of Edo: A Guide to Classical Japanese Flowers*. PIE International, Tokyo.

Tanaka, Junko, Iwatsu, Tokio, Murata, Hiroko, Murata, Jin and Yamanaka, Masumi. (2019). *Honzō Zufu*, and how a copy came to be in the Kew Library. *Curtis's Botanical Magazine*. Volume 36/1.

Thunberg, Carl Peter. (1975). *Flora Japonica: Sistens Plantas Insularum Japonicarum*. Reprint of 1784 edition. Oriole Editions, New York.

Thunberg, Carl Peter, et al. (1994). *C. P. Thunberg's Drawings of Japanese Plants: Icones Plantarum Japonicarum Thunbergii*. Maruzen Co. Ltd, Tokyo.

Watt, Alistair. (2017). *Robert Fortune: A Plant Hunter in the Orient*. Royal Botanic Gardens, Kew.

Willis, Kathy and Fry, Carolyn. (2014). *Plants from Roots to Riches*. John Murray, London in association with the Royal Botanic Gardens, Kew.

Yamanaka, Masumi and Rix, Martyn. (2017). *Flora Japonica*, revised edition. Royal Botanic Gardens, Kew.

Online

https://dl.ndl.go.jp/info:ndljp/pid/1287115 – *Honzō Zufu* online as part of the National Diet Library Digital Collections, Japan

www.biodiversitylibrary.org – the world's largest open access digital library specialising in biodiversity and natural history literature and archives, including many rare books.

www.kew.org – Royal Botanic Gardens, Kew website with information on Kew's science, collections and visitor programme.

www.plantsoftheworldonline.org – an online database providing authoritative information of the world's flora gathered from the botanical literature published over the last 250 years.

ACKNOWLEDGEMENTS

Kew Publishing would like to thank the following for their help with this publication: Kew botanical artist Masumi Yamanaka; Editor of *Curtis's Botanical Magazine*, Martyn Rix; botanical and horticultural experts Phillip Cribb, Tony Kirkham, David Mabberley, Masaya Tatebayashi, Jin Murata, Steve Renvoize, David Simpson; in the Library, Art and Archives Fiona Ainsworth, Craig Brough and Anne Marshall; for digitisation work, Paul Little.

INDEX

© The Board of Trustees of the Royal Botanic Gardens, Kew 2020

Illustrations © the Board of Trustees of the Royal Botanic Gardens, Kew, unless otherwise stated

The authors have asserted their rights as authors of this work in accordance with the Copyright, Designs and Patents Act 1988

All rights reserved. No part of this publication may be reproduced, stored in a retrieval system, or transmitted, in any form, or by any means, electronic, mechanical, photocopying, recording or otherwise, without written permission of the publisher unless in accordance with the provisions of the Copyright Designs and Patents Act 1988.

Great care has been taken to maintain the accuracy of the information contained in this work. However, neither the publisher, the editors nor authors can be held responsible for any consequences arising from use of the information contained herein. The views expressed in this work are those of the authors and do not necessarily reflect those of the publisher or of the Board of Trustees of the Royal Botanic Gardens, Kew.

First published in 2020
Royal Botanic Gardens, Kew,
Richmond, Surrey, TW9 3AB, UK
www.kew.org

ISBN 978 1 84246 721 3

Distributed on behalf of the Royal Botanic Gardens, Kew in North America by the University of Chicago Press, 1427 East 60th St, Chicago, IL 60637, USA.

British Library Cataloguing in Publication Data
A catalogue record for this book is available from the British Library

Design: Ocky Murray
Page layout and image work: Christine Beard
Production Manager: Jo Pillai
Copy-editing: Michelle Payne

Printed and bound in Italy by Printer Trento srl.

Front cover image: *Paeonia lactiflora*, shakuyaku, peony, Volume 9

Endpapers: *Lilium auratum* var. *rubrovittatum*, Japanese golden ray lily, Volume 51

p2: *Prunus mume*, Tobe ume-pink, Japanese plum, Volume 61

p4: *Chrysanthemum* x *morifolium*, chrysanthemum, Volume 13

p10: *Aesculus turbinata* Japanese horse chestnut, Volume 62

For information or to purchase all Kew titles please visit shop.kew.org/kewbooksonline or email publishing@kew.org

Kew's mission is to be the global resource in plant and fungal knowledge and the world's leading botanic garden.

Kew receives approximately one third of its funding from Government through the Department for Environment, Food and Rural Affairs (Defra). All other funding needed to support Kew's vital work comes from members, foundations, donors and commercial activities, including book sales.

Publisher's note about names
The scientific names of the plants featured in this book are current, Kew accepted names at the time of going to press. They may differ from those used in original-source publications. The common names given are those most often used in the English language, or sometimes vernacular names used for the plants in their native countries.

OTHER TITLES IN THE
KEW POCKETBOOKS SERIES

Cacti

Palms

Honzō Zufu

Japanese Plants

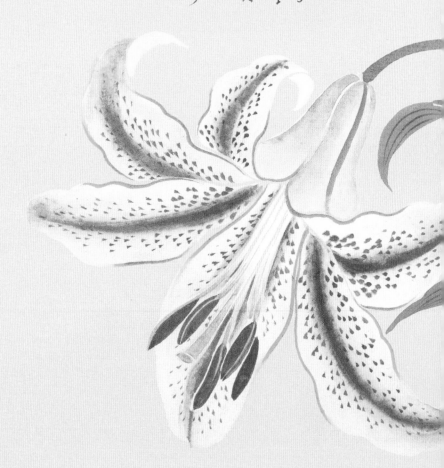

形状芳野ゆりに
似て葉青色高
さ三四尺夏花あり
大さ五六寸白色に
して瓣の中竪に毋
色の筋あり紅
点あり甚く美し